Love

GW00776093

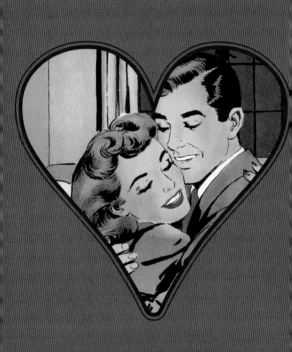

LITTLE BOOK OF VINTAGE

Love

TIM PILCHER

ILEX

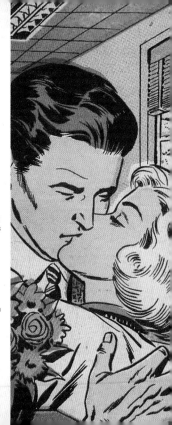

⬤ LITTLE BOOK OF VINTAGE: LOVE

First published in the UK, US, and Canada
in 2012 by

I L E X
210 High Street
Lewes
East Sussex BN7 2NS
www.ilex-press.com

Publisher: Alastair Campbell
Creative Director: Peter Bridgewater
Managing Editor: Nick Jones
Senior Editor: Ellie Wilson
Commissioning Editor: Tim Pilcher
Art Director: Julie Weir
Designer: Simon Goggin

British Library Cataloguing-in-Publication Data
A catalog record for this book is available
from the British Library.

ISBN: 978-1-78157-004-3

Printed and bound in China

Color Origination by Ivy Press Reprographics

10 9 8 7 6 5 4 3 2 1

Ace of Space font courtesy of
Ace of Space Graphics
www.aceofspace.com

Contents

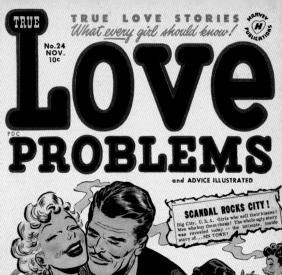

TRUE LOVE STORIES

What every girl should know!

HARVEY PUBLICATIONS

TRUE

No. 24
NOV.
10c

Love

PDC

PROBLEMS

and ADVICE ILLUSTRATED

SCANDAL ROCKS CITY !

Big City, U.S.A. Girls who sell their kisses!
Men who buy them cheap! The whole ugly story
was revealed today -- the intimate, inside
story of... SIN TOWN!

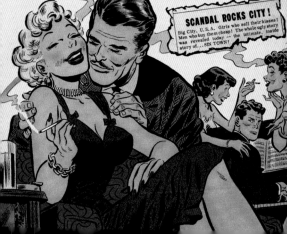

Introduction

"Love is a many splendid thing."

"Love lifts us up where we belong."

"All you need is love."

Just as endless songwriters have exulted the astonishing highs and lows of romance, so have comic creators, starting with Joe Simon and Jack Kirby (the creators of *Captain America*), who launched *Young Romance* way back in September 1947. "It was supposedly very risky to put out love stories for children," recalled Simon. "But we knew that a lot of comic book readers were high-school age and, as a result, they wanted to read about people a few years older, so that's how we approached *Young Romance*. We never talked down, and we were very realistic and adult. Nobody else knew how good we were doing for a couple of years, and then they caught on, and everybody started copying us."

Simon & Kirby sparked a riot of copycat titles and by the end of 1949 there were over 125 romance comics filling the stands every month. "The kids really liked what we were trying to do," continued Simon in an interview with David Hajdu. "I think because we didn't treat them like kids. We were practically kids ourselves, you know, so we didn't look down on them." And the kids rewarded Simon and Kirby each with an impressive $1,000 (£627) a month salary—the equivalent of $9,000 (£5,600) today—after Simon had cannily negotiated a deal giving the creators a 50% profit split with the publishers, Crestwood.

These heart-rending stories often warned of the dangers of falling for the wrong boy, but it wasn't only the comics that were filled with louche Lotharios, the creators themselves had a reputation as well. Matt Baker—possibly one of the greatest comic artists of the period—was a handsome, tall African American with an eye for the ladies. The dapper dresser drove a yellow convertible coupe and fellow artist Bob Lubbers recalled, "All the women, white and black, went crazy for him, and I know he had a bunch of gals on the hook . . . He was the envy of everybody."

These steamy stories of unrequited love, tragic heartbreak, and uplifting romance filled the newsstand racks for decades, but, as Bryan Ferry once sang, "Nothing lasts forever," and eventually the bottom fell out of the romance comics business with *Young Love* #126 in 1977.

This intriguing collection of classic comics clips contains helpful tips, from finding out "Which is Your Dream Man?" to "How to Increase Your Dateability!" Plus, there's all the usual ads, full-page splashes, kitsch covers, and, of course, real-life Agony Aunt letters. So feast your eyes on the beautiful moments within this tempting, teasing sampler of classic Fifties romance comics. After all, "The greatest thing you'll ever learn, is just to love and be loved in return."

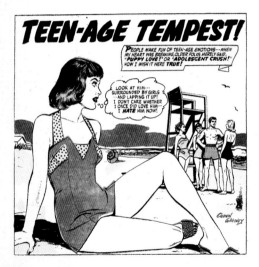

QUALITY ROMANCE CHICAGO

BRIDES ROMANCES

NOVEMBER No. 14

10¢

"When I fell for handsome Steve Adams, I kept it a secret hidden within my heart! How could I compete with glamorous, successful Julia Bishop? I was only her secretary..."

See—

MY MAN LOVED ANOTHER

OH, STEVE, WHY DID I HAVE TO FALL IN LOVE WITH YOU... WHY?

HEAVEN IS RIGHT HERE

FIRST LOVE
I MADE MY CHOICE

The ORIGIN OF MARRIAGE Customs!

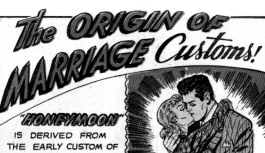

"HONEYMOON" IS DERIVED FROM THE EARLY CUSTOM OF PROVIDING A NEWLY-WEDDED COUPLE WITH A HONEY-LIKE WINE FOR **ONE MONTH** AFTER THE MARRIAGE! THUS... THE COMBINATION OF "HONEY" AND "MOON"... (MONTH)

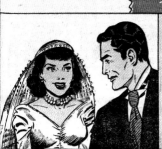

ORIGINALLY THE **BRIDAL VEIL** WAS A SQUARE PIECE OF CLOTH HELD OVER THE BRIDE'S FACE DURING THE CEREMONY... TO **HIDE HER BLUSHES!**

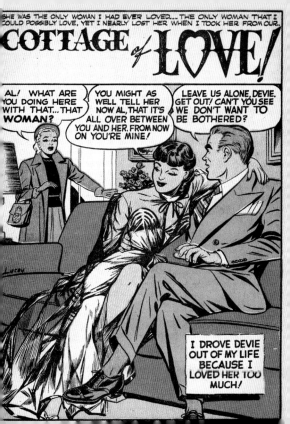

Have No Fear

by May Richstone

Have no fear, my love, of me—
It's just your friend I want to be.

No mating call lurks in my voice
Declaring you the man of my choice;

No designing glint is in my gaze,
No protective, tender haze,

So don't resist me quite so hard—
Relax, my love, let down your guard!

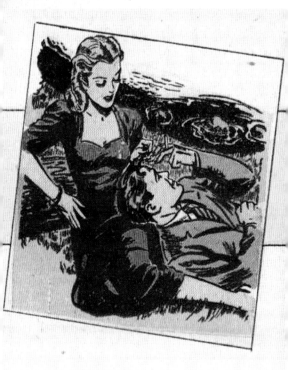

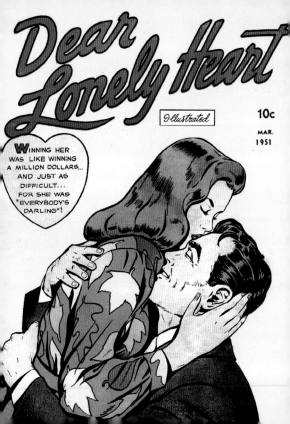

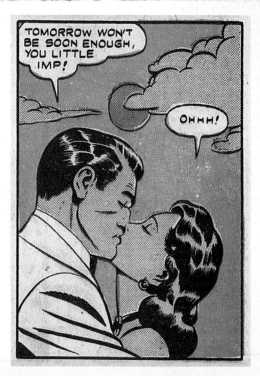

IS IT BETTER TO HAVE LOVED AND LOST···
THAN NEVER TO HAVE LOVED AT ALL?

TRUE LOVE

FIRST ROMANCE

magazine

No. 31
DEC.
10¢

I'VE NEVER KNOWN
A LOVE LIKE
OTHER GIRLS.
AM I WRONG
TO BE···

SORRY
FOR
MYSELF!

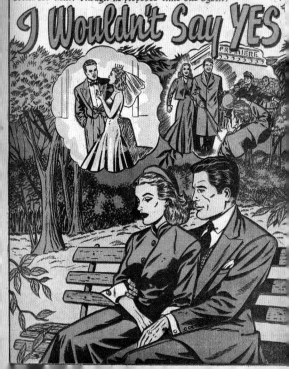

Love in a grand manner had always been my dream! I visualized myself married to a handsome man of extreme wealth or perhaps someone of prominence like a famous movie actor! That's why, though I had gone with Jeff Stevens for several years, I couldn't bring myself to settle for him! Though he proposed time and again,

I Wouldn't Say YES

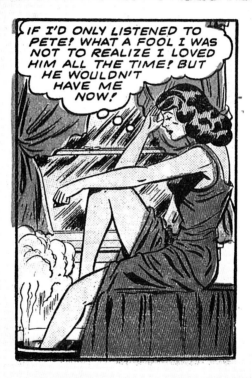

To GLORIA, a man was a challenge! Not just any man, of course, but a charming, attractive man, preferably a man who belonged to another girl! There was a thrill in the difficult chase, for Gloria did not believe in crude, obvious tactics.

For instance, she never flaunted her beauty brazenly, but used it almost as an accessory, to play up her pose of sincere interest and understanding. But of course, the large blue-green eyes and the golden silky hair helped!

There had been snobbish Prudie Fischer, whose wealthy family had imported some out-of-town man for her! Gloria had made his head spin in three easy "accidental" meetings. When she'd won him, she'd sent him back to Prudie Fischer, who married him.

Elsa Byers, who fancied herself such a femme fatale, lost her favorite man to Gloria one evening at a party. She'd been so possessive about him, that Gloria had not been able to resist the temptation.

Not that she *wanted* any of these men! "Not for me!" Gloria would laugh in rare bursts of confidence to Karen, her only real friend.

"Then why do it? It's . . . mean, Gloria! Really cruel and heartless of you!"

"I . . . I don't exactly know for certain," Gloria had confessed. "Some people like to drive fast! Others like to gamble or fly planes. Me, I like to upset the applecart in my own way!"

"Some day," Karen had predicted darkly, "*your* applecart will be upset!"

Was she right?

Gloria had worried that question for weeks, now, ever since Ted Malcolm had come to town. You see, Ted was not only charming and attrac-tive, but he belonged to . . . *Karen!* Gloria had seen them together dozens of times, laughing, holding hands, shutting the rest of the world out.

"Shutting *her* out!" she thought bitterly. But for the first time, there was a twinge of conscience where Gloria's heart should have been! For she'd tried to woo and win Ted away. And Karen had *let* her, giving her every opportunity to take him!

"But . . . he . . . doesn't *want* me!" At last, it was out, in so many words! For the first time, a man had resisted her, refused to be lured. And Gloria, half-shocked into feeling, had lost her sense of humor about the chase. For she had made a heart-breaking discovery!

"If *this* is how it feels, I . . . I *have* been cruel! I've been *worse* than cruel, worse than anything Karen called me!"

Gloria had fallen in love, really in love, with the one man who didn't want her! "I've got to stay away from him," she thought desperately. "Did Prudie feel like this when I took her man away? Or Elsa? I took Karen go through it . . . and besides . . . he doesn't know I'm alive!"

It was when she'd decided to leave town that she phoned Karren to say goodbye. "I'll see you off," Karen had said. She brought Ted to the train, too, and Gloria's heart contracted.

But Ted took her hands and said quietly, "*Must* you go? I'd rather you didn't!"

Gloria looked at Karen, a question in her eyes. "Do you *want* to stay?" Karen asked. "For . . . *Ted?*" She smiled and Gloria knew what Karen had done. She'd *coached* Ted, taught Gloria the lesson she needed!

"Thanks, Karen," she said meekly, "I'm staying!"

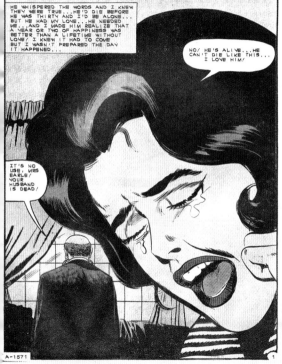

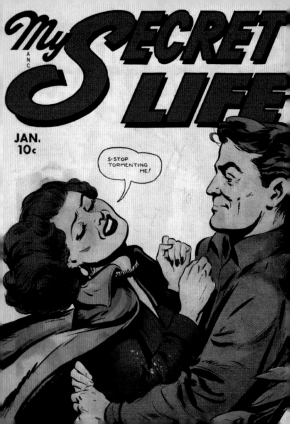

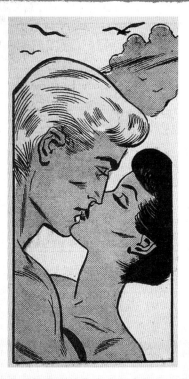

HOW TO INCREASE

Some tips on how to up

IF, YOU FEEL YOU'RE NOT AS POPULAR AS YOU *MIGHT BE*, ARE YOU SURE YOU'RE AS *ALERT* AS YOU COULD BE? PERHAPS THE FELLOW WHO WORKS AT THE NEXT DESK IS A LITTLE SHY-- MAYBE HE'S BEEN THROWING HINTS YOUR WAY AND *YOU HAVEN'T BEEN CATCHING THEM!*

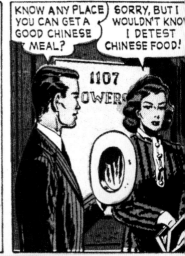

KNOW ANY PLACE YOU CAN GET A GOOD CHINESE MEAL?

SORRY, BUT I WOULDN'T KNOW I DETEST CHINESE FOOD!

OUR DATEABILITY!

ur popularity quotient.

ARE YOU MAKING THE **MOST** OF AVAILABLE OPPORTUNITIES TO MEET YOUNG MEN YOUR AGE? IN SHORT, DO YOU GO PLACES WHERE THE YOUNG MEN ARE? JOIN A SOCIAL CLUB OR TRY THE SWIMMING POOL AT THE LOCAL "Y"! YOU MIGHT BE SURPRISED AT THE RESULTS!

THIS IS NO TIME TO BE TOO PROUD! LET YOUR FRIENDS *KNOW* YOU'D LIKE TO MEET SOME ELIGIBLE YOUNG MEN! THEY'RE USUALLY VERY GLAD TO COOPERATE!

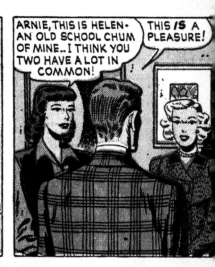

ARNIE, THIS IS HELEN- AN OLD SCHOOL CHUM OF MINE.. I THINK YOU TWO HAVE A LOT IN COMMON!

THIS *IS* A PLEASURE!

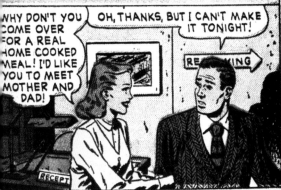

ARE YOU TOO ANXIOUS? DOES YOUR WHOLE ATTI-TUDE ADVERTISE THE FACT THAT *YOU'RE MAN HUNGRY?* BE CAREFUL NOT TO SCARE POTENTIAL DATES AWAY WITH OVER EAGERNESS!

WHY DON'T YOU COME OVER FOR A REAL HOME COOKED MEAL! I'D LIKE YOU TO MEET MOTHER AND DAD!

OH, THANKS, BUT I CAN'T MAKE IT TONIGHT!

RE_____ING

RECEPT___

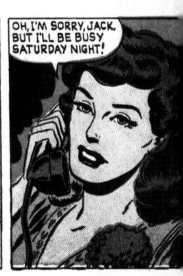

PERHAPS YOU'RE SO BUSY WAIT-ING FOR YOUR **DREAM MAN** TO COME ALONG YOU'RE OVER-LOOKING SOME VERY GOOD BETS! SOME-TIMES A GIRL HAS SUCH A DETAILED PIC-TURE OF HER "HERO" IN MIND THAT SHE OVER-LOOKS HIM IF HE SHOULD SHOW UP IN SLIGHTLY DIFFERENT GARB!

OH, I'M SORRY, JACK, BUT I'LL BE BUSY SATURDAY NIGHT!

ARE YOU **FRIENDLY AND SWEET** TO EVERYONE-NOT JUST THE MEN ON WHOM YOU WANT TO MAKE AN IMPRESSION! PERHAPS-JUST PERHAPS THE NICE OLD COUPLE DOWN THE STREET MAY BE THE ONES TO INTRO-DUCE YOU TO *HIM* IF THEY LIKE YOU!

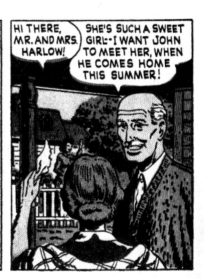

HI THERE, MR. AND MRS. HARLOW!

SHE'S SUCH A SWEET GIRL-I WANT JOHN TO MEET HER, WHEN HE COMES HOME THIS SUMMER!

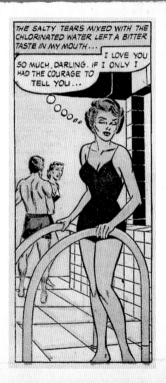

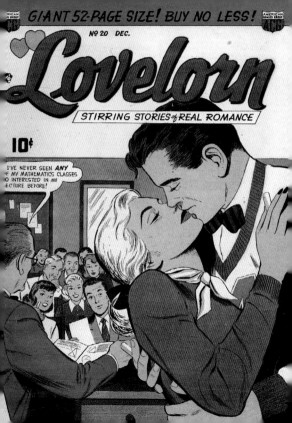

MY SECRET LIFE

End

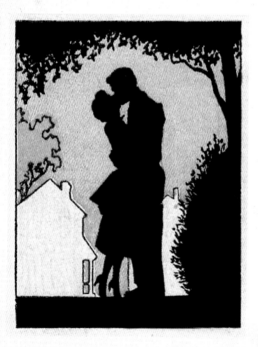

AND BE MY LOVE

THE ambulance roared away from the Martin Avenue Settlement House, its siren wailing in the warm summer night. Watching it from the window of her office, Mary wondered how many times in the last three years she had seen an ambulance rushing away like that from one of the tenements in the district, and a scowl wrinkled her freckled face as she returned to her desk. Poverty, hunger and dirt, dangerous streets for playgrounds, dilapidated buildings for homes, crime and sickness and death! And when would it end? When would decent people be given a decent chance to work when decent lives? "Society injured that boy," she said hotly. "If he'd had a decent place to play that truck would never have hurt him. You can't play stickball in the street without—"

But Mr. Edmonton had not come to her office to hear a talk on the obligations Society has to its children. A short, plump man with a bald pate and sharp blue eyes, he thumped his fist on the desk. "We were discussing you and my son, Miss Healy, and if you don't mind I'm in something of a hurry. Come, I have made a good offer. A new wing for this house plus a fine playground, and all I ask in return is that you refuse to marry Jerry. And it isn't as though he'll marry you against my will. Understand, you really have no choice."

Life without Jerry? Just the thought filled her with pain. No more kisses under a starlit sky. No more walks in the shadowed stillness of the park. She sucked in her breath, every inch of her crying out vehemently against it. And in that moment, hatred so intense it was difficult to remain in her chair. "You—you should be ashamed of yourself," she said huskily. "You ask me to give up everything I've ever wanted in exchange for money you will never miss. You aren't Jerry's father! He couldn't have such a father! Jerry is sweet and gentle and kind, and you—you're a fiend."

"I've been called worse." He chuckled and went over to the window and stared down into the street. Already boys were playing another game of stickball and he shook his head in wonder. "They never learn, do they? Five minutes ago one was almost killed, but there they are—"

"Where else can they play? Or has the great Mr. Edmonton decided it's a sin for them to play?"

"They could play on the playground I would build." He smiled as her eyes wavered, gray eyes that were as lovely as Jerry had said they were. Come, Miss Healy. There will be other men . . . A girl as lovely as you—" he fell back, gasping, as her slap caught him squarely across the mouth. "How dare you! By thunder . . ."

"Get out!" Her face pale with fury, she opened the door. Later there would be tears and bitter loneliness, but she gave no thought to that now. "Get out, you hear?"

"Then your answer is yes?"

A sob tore from her, a sob he had heard before, the sob of a man trapped, a woman broken. Dumbfounded, he took a little step forward. And now it was his turn to be unsure of himself. "You—you would actually give up Jerry for those children?"

"They have a right to play, to live. Please, you have what you came for, haven't you? I won't see Jerry again. That—that's a promise."

"But why? Hang it, will you tell me why?"

She dabbed at her eyes with her handkerchief. "It's my job to help them that's why. But you wouldn't understand that Mr. Edmonton. And I'm not in the mood to explain. All right Jerry won't marry beneath him, but it will cost you, it will cost you a lot."

She rushed to the desk to get the figures and plans Jerry himself had helped her draw up, but Mr. Edmonton's chuckle halted her. She whirled around. "You—you—JERRY!"

"Hello, darling." His face solemn, he came into the office and shot his father an angry gland. "Now are you satisfied?"

She threw herself into his arms. "Jerry, he won't accept me. Jerry, we can't be married. Jerry . . ."

Mr. Edmonton chuckled again. "Rubbish, my dear child. I'm a man who worked his way to the top and, if a working girl was good enough to be my wife, then a working girl is good enough for my son. But she had to be a sincere social-worker, a woman who would give up everything to help those in need of help—the way my wife did. So Jerry was good enough to wait in the hall and—drat it, I'm talking to you!"

BUT Mary wasn't listening, nor was Jerry. In one another's arms, his lips pressed softly against hers, they were far, far away in a world all their own. "O, come with me and be my love," Jerry murmured. "Mary, we'll be happy and the kids will be happy and—oh, Mary, you're so beautiful!"

THE END

Romantic story

Be an eyewitness...
to the most personal moments of
young people experiencing the
poignant affairs of the heart...in
ROMANTIC STORY

10¢ ON SALE AT YOUR FAVORITE NEWSSTAND 10¢

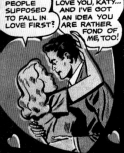

A QUALITY ROMANCE PUBLICATION

ANC

APPROVED BY THE COMICS CODE AUTHORITY

Girls In Love

SEPTEMBER
No.46

10c

MAY 26

When Vance Eldridge disappeared two days before our wedding, I started off on a desperate search until——

VANCE!

WELL.... IF IT ISN'T THE GIRL I LEFT BEHIND ME! WHAT ARE **YOU** DOING HERE?

See SOMEWHERE I'LL FIND YOU

He Was No Good
UGLY DUCKLING
My Two Popular Boyfriend

RUSTIC CINDERELLA

...Every girl dreams of marrying her "prince charming," but few girls ever have the love of a REAL prince thrust at their feet...

In a sun-drenched day many years ago, Elaine Taggart worked in her father's hayfield. She mused as a beautiful carriage came down the road...

OH, THAT MUST BE THAT FOREIGN PRINCE WHO IS VISITING THE GOVERNOR! I'VE HEARD HE IS VERY HANDSOME!

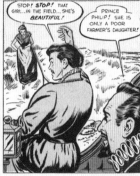

STOP! STOP! THAT GIRL...IN THE FIELD...SHE'S BEAUTIFUL!

PRINCE PHILIP! SHE IS ONLY A POOR FARMER'S DAUGHTER!

BUT, PRINCE..

GOVERNOR, MONEY AND FINE CLOTHES COULD NOT CREATE SUCH BEAUTY. THIS IS THE GIRL I HAVE SEARCHED THE WORLD FOR, THE ONE GIRL I KNEW I WOULD SOMEDAY FIND!

I DON'T UNDERSTAND! YOU'RE...YOU'RE FLATTERING ME!

NO, I AM SINCERE! FATE HAS LED ME TO YOU...AND I SHALL NEVER LET YOU OUT OF MY SIGHT AGAIN!

I...I CAN'T BELIEVE THIS...A PRINCE! STILL MY HEART GOES OUT TO YOU.

Yes, and Elaine's dreams all came true.. when she became Princess Elaine . Real-life proof that dreams can come true.. and that Cinderellas do exist outside of the pages of storybooks.

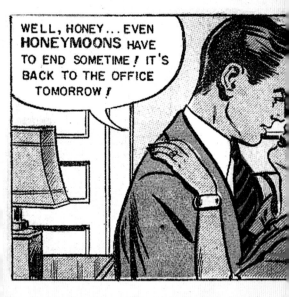

Advice on Love Problems

By Marilyn Minton

Dear Marilyn Minton :

I am a constant reader of your advice to others and I hope you can supply the answer to my problem. My boyfriend and I are quite serious about each other and some day hope to marry. We both have jobs, only I make more money than he does. Also, when we go out on dates, I like to go to nice places to dance and he says they are too expensive for his pocketbook. Since I am making good money, I want to pay for some of these dates but he won't stand for that. He says if we can't go out on his money, we won't go at all. Since we will eventually be married and I will probably help the family budget along then, do you seen anything wrong in my paying for some of our dates now? Please tell us what you think we should do.

Marjorie T.
Dallas, Texas

Dear Marjorie T.

You have a problem that is not uncommon these days, however, if you are genuinely fond of this young man, you should be content to have dates with him which he can afford. Although in recent years it has become acceptable to go "dutch treat" with the boy and the girl each paying his and her own way, it is not correct for the young lady to pay for the whole date at any time. You should respect your boyfriend's feelings about this and be glad that he has the pride and self respect to want to be entirely responsible for financing your dates.

Marilyn Minton

Dear Marilyn Minton :

I have read your advice to others and I a sure that you can help me solve my problem have liked one boy for almost three years b he has never known that I was alive. This ye I have three classes with him at school, and h speaks to me sometimes when we are char ing classes. He belongs to another group tha mine, so it is almost impossible that he mig ask me for a date. I'm sure that if he asks r once, we will get along fine and he will ask m for a date again. Can you tell me what mig help to get him to ask me out? I've tried almo everything except asking him. I don't thin that I've been over-anxious though.

D.
Georgetown.

Dear D.P.

I think you can feel reasonably sure th the young man you mention was aware your existence long before you met in th same classes at school. However, even thoug he may find you attractive, he is liable to b slow about asking you for a date. In such a instance, some initiative may be exercised by lady, but the only time when I would consid it proper to ask a boy out would be if you in vited a group of young people to your hom In that case, he would be just another gues and not your particular date. Once you hav been in a social gathering together, it wou open the way for him to ask you for a date. any event, be gracious and charming at a times. It's woman's way of working wonders.

Marilyn Minto

"IT DIDN'T TAKE ME LONG TO FIND OUT THAT REX WAS NO AMATEUR AT ROMANCE. HIS KISSES WERE EXCITING AND HIS FLATTERING PROMISES SWEPT AWAY THE PAINFUL MEMORIES OF HOME..."

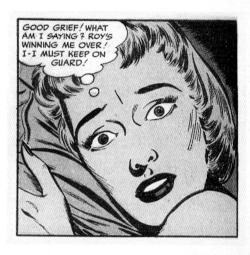

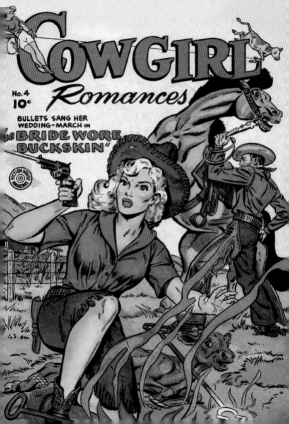

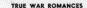

I WOULDN'T ALLOW MYSELF TO BECOME INVOLVED IN A ROMANCE THAT WASN'T SINCERE! BUT WHEN THE REAL THING DID COME ALONG I COULDN'T CAPTURE THE HEART OF THE MAN I LOVED! PRIVATE CLYDE LANE SHUNNED MY AFFECTION FILLING MY MIND WITH ONE TERRIBLE THOUGHT...

Was There Another Girl?

I'LL... BE WAITING!

OH, CLYDE! YOU'RE THE ONE... THE ONLY MAN I EVER WANTED! WHY ARE YOU SO COLD? WHY WON'T YOU RETURN MY LOVE? WHAT'S WRONG?

GOOD NIGHT, JUNE! PERHAPS I'LL GIVE YOU A CALL WHEN I HAVE THE TIME!

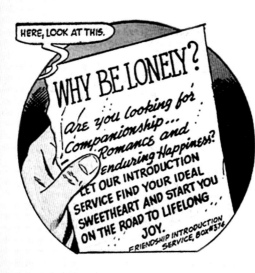

ANN, ANN, DARLING, YOU'RE SO WONDERFUL! DO YOU KNOW HOW MUCH I'VE COME TO CARE FOR YOU IN JUST THE FEW SHORT DAYS I'VE KNOWN YOU?

NO, CLIFF.. PLEASE, TAKE ME HOME... I.. I DON'T WANT TO FALL IN LOVE WITH YOU, CLIFF.. I DON'T ADMIRE YOU!

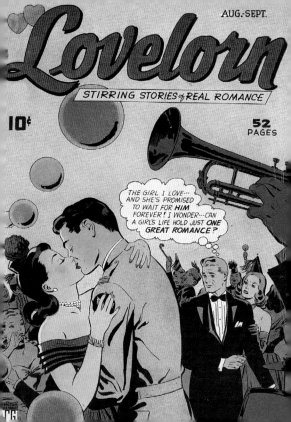

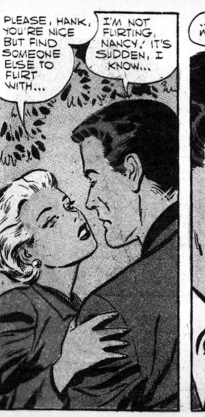

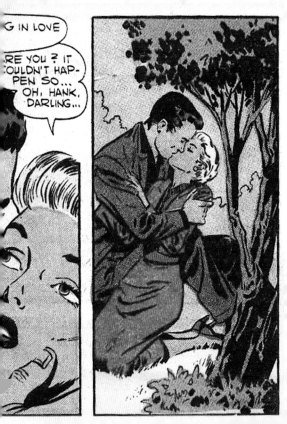

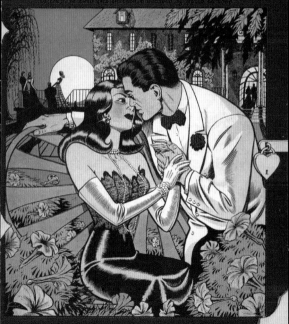

LOVE DIARY

10¢

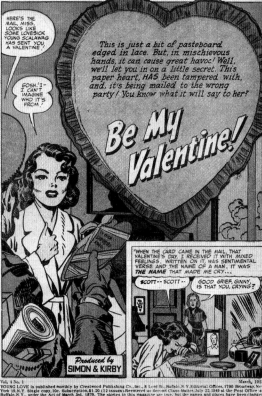

Vol. 4 No. 1 March, 1952
YOUNG LOVE is published monthly by Crestwood Publishing Co., Inc., 8 Lord St., Buffalo, N.Y. Editorial Offices, 1790 Broadway, New York 19, N.Y. Single copy, 10c. Subscription, $1.20 (12 issues). Reentered as Second Class Matter, July 22, 1949 at the Post Office at Buffalo, N.Y., under the Act of March 3rd, 1879. The stories in this magazine are true, but the names and places have been changed and should not be identified with any actual person living or dead. No responsibility is assumed for unsolicited manuscripts. Entire contents copyrighted 1951 by Crestwood Publishing Co., Inc. Printed in the U. S. A.

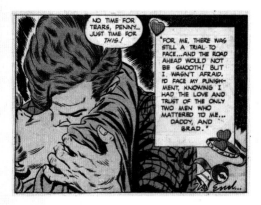

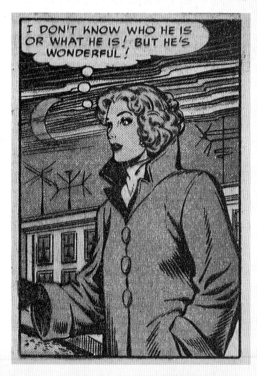

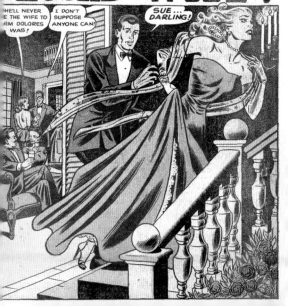

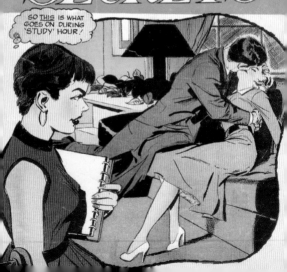

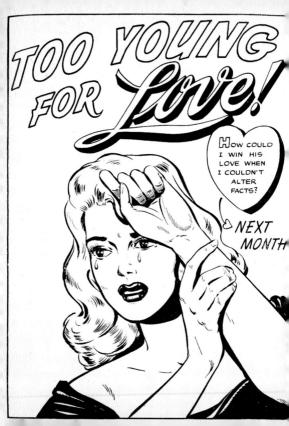

My Bashful Boy-Friend

OH, PAUL, I KNOW YOU'RE ATTRACTED TO ME! BUT WHY WON'T YOU SAY SO? YOU'RE THE ONLY BOY HERE WHO HASN'T ASKED ME FOR A DANCE!

THEY CALLED ME THE BUSIEST AND MOST POPULAR GIRL IN COLLEGE! I COULD HAVE DATES EVERY NIGHT AND BE IN EVERY ACTIVITY! THEN PAUL BLAKE CAME TO SCHOOL AND SUDDENLY NO ONE ELSE WAS IMPORTANT! I KNEW HE LIKED ME... BUT NO MATTER HOW HARD I TRIED I COULDN'T MAKE HIM SAY SO! I COULDN'T EVEN GET MYSELF ASKED ON A DATE BY HIM!

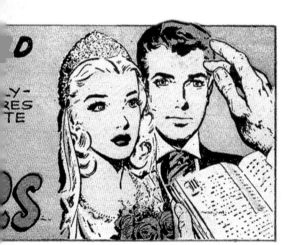

Happy Birthday DARLING!

THE SPECIAL GLOW that comes with having a birthday was in Jane's eyes, making them seem larger, bluer, and more luminous than ever. "That was Frank," she told her mother, as she replaced the telephone receiver, "asking whether he could come over!"

"I hope you said he could!" Jane's mother sounded a bit anxious, as though something were worrying her. It came out in a nervous confession. "I . . . I told him today was your birthday!"

"Mother, *honestly*!" In dismay, Jane started the old argument, but wisely gave it up. It was useless, for her mother insisted on viewing Frank through the rosy mist of his father's money. Everything Frank did or said was wonderful. His car was the latest, most expensive model. His clothes, made to order, were perfection. "If she could marry him *herself*, she would!" Jane thought. "But she can't, so she's pinning her hopes on *me*!"

Jane's dismay was deeper than it appeared, for she too had asked someone over. Ned. And she hadn't mentioned a word about her birthday! It was sure to turn into an embarrassing evening, perhaps even unpleasant.

"There's the door. I'll get it!" Jane's mother, smoothing her hair, was already smiling the gracious smile she reserved for Frank when she opened the door to . . . Ned!

"Oh. Well, hello! Won't you . . . come in?"

The luminous look was back in Jane's eyes as she gave Ned both her hands, responding to the pressure of his with a quickened heartbeat. With the right atmosphere, Ned might have proposed that very night! But that ray of hope was gone, now that . . . the doorbell sounded again!

This time, mother's voice positively dripped hospitality. "Frank! What a lovely package! Those ribbons!"

A study in elegance, Frank handed a small, gift-wrapped box to Jane, throwing a curt greeting to Ned in passing.

"Happy birthday, doll!" Frank said.

"Birthday?" The puzzlement in Ned's face gave way to unhappiness as he met Frank's smug, triumphant glance. "I . . . I didn't know Jane."

"Aren't you going to open the package?" Jane's mother was jubilant.

"Wait a minute, mother." Jane looked steadily at Ned and her heart was in his eyes. "It doesn't matter, Ned," she said gently.

Then Ned was looking at her and the message he read in her face gave him courage. "I . . . I couldn't have competed with Frank's present, anyhow," he said. "You see, all I have to offer is..."

His arms went around Jane as he whispered in her ear. Then, she turned her face to his, offering her lips as freely as she had given her heart.

"Jane!" Mother was aghast.

"It . . . it's a watch . . . with diamonds . . ." Frank was still trying to be the highest bidder.

From the circle of Ned's arms, Jane spoke contentedly, happily. "Thank you very much, Frank, but I'm afraid that I couldn't possibly accept it. You see, my fiancé doesn't approve!"

Ned's kiss took her back into the world of enchantment she had yearned for. "Happy birthday, darling," he said as he drew her close in his arms.

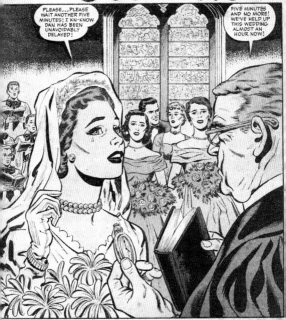

Here are six different

WHICH IS YOU

"I LIKE THE OUT-DOOR TYPE OF MAN, BECAUSE YOU ARE NEVER BORED WHEN YOU'RE WITH HIM. HE ALWAYS KNOWS SO MANY THINGS TO DO! BEING A MAN WHO LOVES NATURE HE IS INVARIABLY CLEAN AND WHOLESOME... SOMEONE YOU'RE REALLY PROUD TO KNOW!

Judith R.

ecies of the Male--

DREAM MAN?

I LIKE A POSSESSIVE MAN, BECAUSE HE MAKES ME FEEL REALLY WANTED! I LIKE THE WAY HE TAKES HOLD OF ME WHEN ANOTHER MAN LOOKS IN MY DIRECTION! WHEN I LIKE SOMEONE, I WANT TO SPEND ALL MY TIME WITH HIM, AND A POSSESSIVE MAN WANTS ALL OF YOUR TIME TOO! I'M NEVER IN DOUBT HOW I STAND HERE!

Susan M.

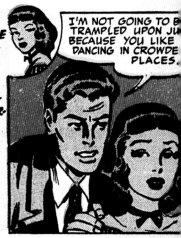

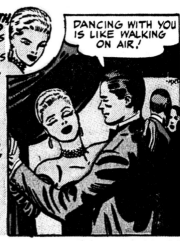

I LIKE A SMOOTH, SOPHISTICATED MAN, WHO TAKES YOU TO NICE PLACES! HE DANCES BEAUTIFULLY, KNOWS A VARIETY OF SPORTS! HE ALWAYS KNOWS HOW TO ENTERTAIN YOU, AND ESPECIALLY IMPORTANT, THE RIGHT THING TO SAY...MAKING A GIRL FEEL WONDERFUL!

Edith D.

DANCING WITH YOU IS LIKE WALKING ON AIR!

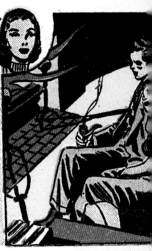

"I LIKE THE HOME-LOVING TYPE OF MAN... ONE WHO DOESN'T WANT TO CHASE AROUND ALL THE TIME. HE'S THE FELLOW WHO LIKES TO SIT IN FRONT OF MY FIREPLACE AND JUST TALK! HE'S EVEN WILLING TO SAMPLE MY AMATEUR ATTEMPTS AT COOKING! THIS IS THE MAN I CAN REALLY RELAX WITH AND JUST BE MYSELF! IN SHORT, HE'S THE GUY FOR ME!

Della S.

I LIKE A MAN WHO TRUSTS ME IMPLICITLY... ONE WHO IS NEVER JEALOUS BECAUSE I HAVE A GOOD TIME WITH SOMEONE ELSE AND WHO KNOWS A LITTLE FLIRTING DOES NO HARM! HE KNOWS I'M HIS GIRL BECAUSE I TOLD HIM I WAS, JUST LIKE I KNOW HE'S MY GUY! HE REALIZES I WOULD NEVER DO ANYTHING TO HURT OUR ROMANCE ANY MORE THAN HE WOULD!

Kathleen R.

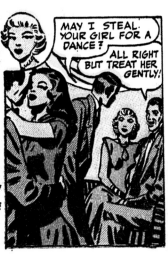

DO **YOU** THINK **I WAS WRONG**?

Working eight hours a day in a factory made my life a dull one. The only dates I could look forward to were for movies and hamburgers with one of the truck drivers at the factory!

No WONDER I GREW HEADY WITH EXCITEMENT AND LOST MY HEART TO A MAN WHO OFFERED ME A FLEETING MOMENT OF GLAMOR...

Had I FORSEEN THE TRAGIC OUTCOME I MIGHT HAVE ACTED DIFFERENTLY!

Read my story

"I WAS NOBODY'S GIRL"

- IN THE SEPTEMBER ISSUE OF

HEART THROBS

On sale June 13th

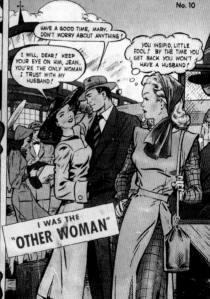

LOVE STORIES

PICTORIAL Romances

10¢

No. 10

HAVE A GOOD TIME, MARY, DON'T WORRY ABOUT ANYTHING!

I WILL, DEAR! KEEP YOUR EYE ON HIM, JEAN, YOU'RE THE ONLY WOMAN I TRUST WITH MY HUSBAND!

YOU INSIPID, LITTLE FOOL! BY THE TIME YOU GET BACK YOU WON'T HAVE A HUSBAND!

...ey said it was wild folly
...d dangerous to do the
...ings that I did...just for a
...nce to become a starlet.

I WAS THE "OTHER WOMAN"

...en it happened...and I
...ad to stand by, knowing
...e awful truth, as my sister
...alked down the aisle.

ALL OF A SUDDEN I DON'T CARE IF MY CAR *NEVER* GETS FIXED! MY NAME'S AL PACE, HONEY-- AND *YOURS* MUST BE ANGEL-FACE!

YOU'RE FLATTER-ING ME, MR. PACE, BUT IT'S A VERY ORDINARY NAME! DELLA MORRIS --DEL, TO MY FRIENDS!

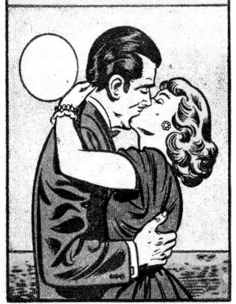

ALL THE FEARS I MIGHT EVER HAVE HAD FLED IN THAT SUPREME MOMENT! ARMANDO LOVED ME!

WHAT WOULD YOU DO IF YOU

MARY M. WRITES

IT ISN'T EASY TO BREAK YOUR TIES, SO PLEASE DON'T CONDEMN ME UNTIL YOU'VE READ WHY "I WAS A MAMA'S GIRL!"

BARBARA H. WRITES

"I WAS AFRAID TO LOVE," AFRAID TO BE HURT... UNTIL I MET THE ONE MAN WHO TAUGHT ME REAL LOVE.

GLADYS B. WRITES

I HID BEHIND ANOTHER GIRL'S LOVE... BECAUSE I WAS ASHAMED OF MY TRUE FEELINGS... REA MY HEARTBREAK ING CASE...

READ THESE TRUE LOVE CONFES

EACH STORY SO TOUCHING IT WILL
A SYMPATHETIC NOTE IN YOUR HEAR
SHARE WITH THEM THE HEARTBRE
AND JOY THAT THEY ENCOUNTERED...
JUDGE FOR YOURSELF. WERE THEY RIC

You'll agree it's the magazine EVERY girl should read!

PLUS
Special Features

ON SALE AT ALL NEWSSTA

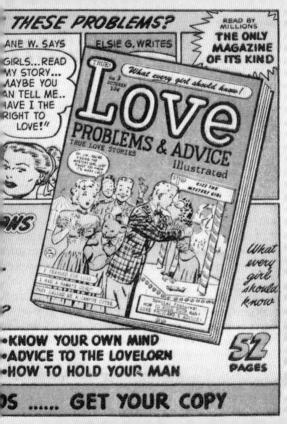

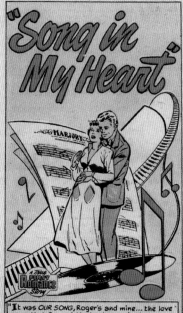

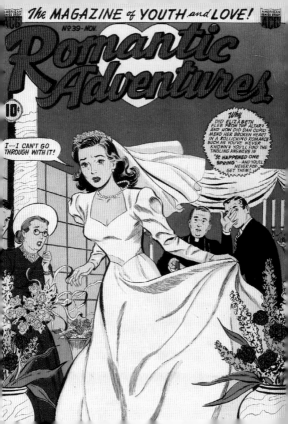

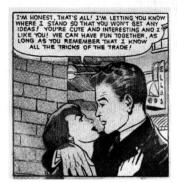

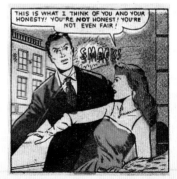

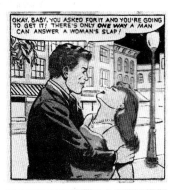

OKAY, BABY, YOU ASKED FOR IT AND YOU'RE GOING TO GET IT! THERE'S ONLY **ONE WAY A MAN** CAN ANSWER A WOMAN'S SLAP!

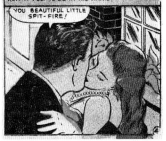

HIS LIPS CAME DOWN ON MINE AND STAYED THERE A LONG TIME. I KNEW EVEN AS I STRUGGLED AGAINST HIM THAT, NO MATTER HOW HARD I TRIED TO HATE HIM, I WOULD NEVER FORGET HOW IT FELT TO BE IN HIS ARMS!

YOU BEAUTIFUL LITTLE SPIT-FIRE!

LOTS OF ROMANCES THAT **MIGHT** HAVE BEEN NEVER BLOSSOM FORTH---BECAUSE THE GIRL CAN'T RISE ABOVE COMPETITION AND CALL HERSELF TO THE MAN'S ATTENTION! IF **YOU'VE** HAD THAT SORT OF TROUBLE, HERE ARE A FEW HELPFUL HINTS! USE THEM CAREFULLY, FOR THEY'LL TEACH YOU...

HOW to MAKE HIM NOTICE YOU!

IF YOU'RE LIKE MOST OTHER GIRLS, YOU'VE HAD YOUR SHARE OF DATES---

WHY, YES, TOM!

SURE THING TED!

BE GLAD TO GO, JOE!

THERE ARE GENERALLY GUYS AROUND WHEN YOU WANT THEM---YOU'RE NOT LEFT ON THE SHELF---

NOW, YOU DIDN'T EXPECT TO KEEP HER ALL TO **YOURSELF**, DID YOU?

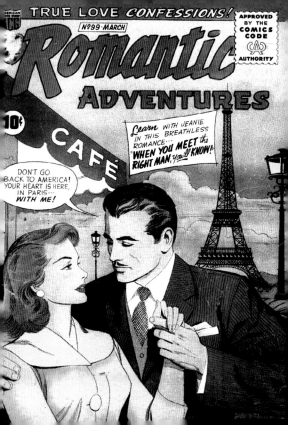

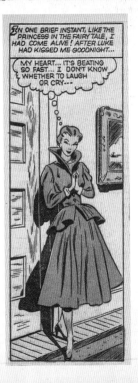

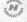

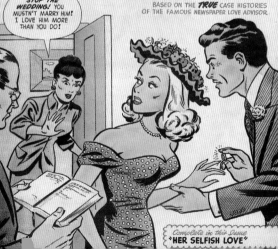

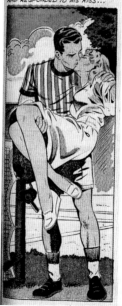

BUT THERE WAS NO USE PRETENDING... WE SEEMED TO BE DRAWN TO EACH OTHER. SUDDENLY HIS LIPS WERE ON MINE, AND ALL THOUGHTS ABOUT MY FAITHFULNESS TO MY 'HUSBAND' VANISHED AS I LOST MYSELF IN HIS ARMS AND RESPONDED TO HIS KISS...

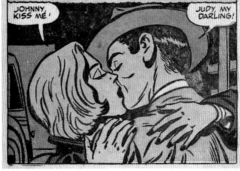

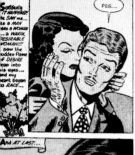

PEG...

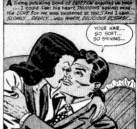

A living, pulsating bond of EMOTION engulfed us both... I could feel his heart THUDDING against mine... his LOVE for me was awakened at last! And I sank SLOWLY... DEEPLY... into WARM, DELICIOUS ECSTASY!

YOUR HAIR... SO SOFT... SO SHINING...

And at last...

PEG, I--I DON'T KNOW WHAT TO--TO SAY--

DON'T SAY ANYTHING, JOHN... DARLING...

JUST... KISS ME-- AGAIN...

NO, PEG-- I DON'T DARE...

I'VE GOT TO THINK, PEG! I-- I'LL SEE YOU TOMORROW --IN THE OFFICE--

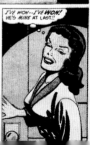

I'VE WON--I'VE WON! HE'S MINE AT LAST!!

<center>* * *</center>

Dear *Lonely Heart*: I am being married next fall and my mother insists on a big wedding. When we went over the list of guests I noticed she had included two of my old flames. I don't think this is proper, what do you think?

<div align="right">Bride-to-be</div>

Dear Bride-to-be: If they are friends of your family and if your future husband also knows them, or even if he doesn't I don't see any harm in inviting them. You seem to forget that they aren't important to you any more, you have chosen another. If you're not sure of this, my dear, you're not ready to marry yet.

<center>* * *</center>

Dear *Lonely Heart*: I like a boy well enough to go steady with him. There is only one thing I can find wrong with him. He is not romantic. I know he loves me, but I wish he could show it a little more. Is there anything I could do to make him romantic?

<div align="right">Betty</div>

Dear Betty. I doubt that there is. You were attracted to him in the beginning without his romantic nature weren't you? I have a feeling that you will find more character in this quiet boy than in another who would sweep you off your feet with a lot of silly love-making. My advice is not to try to change him, but to adjust your own personality to blend with his. Sweet talk isn't everything, Betty, is it?

<div align="right">*L.H.*</div>

<center>* * *</center>

Dear Readers: If I can help you solve a problem don't hesitate to write to me at the below address. All mail is confidential.

<center>

Lonely Heart

ARTFUL PUBLICATIONS
342 Madison Avenue
New York City, N.Y.

</center>

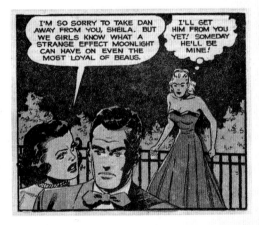

STORIES OF

Brides *in* Love

A CHARLTON PUBLICATION

10¢

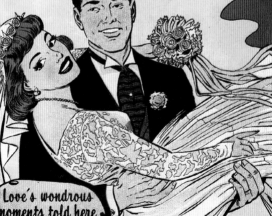

Love's wondrous moments told here on these pages!

NICHOLAS ALASTA

LET THE STA[RS]
GUIDE YO[U]

FOR A HAPPY LOVE LIFE

Is your sweetheart worth the love and devotion you g[ive]
Will he make the best mate for you—to live with thro[ugh]
out the years? Look up his birthday and your own in [the]
Halgar L[o]ve Guide and you'll find out if your pers[onal]
ities are destined to clash eventually, or if you are [per]
fectly suited to each other. The Love Guide will give [you]
a helpful insight to his likes and dislikes, his weakne[ss]
and his strength of character. It will tell you what t[o do]
to bring and hold the two of you together for a fru[itful]
long and happy love life. Get your copy of the Ha[lgar]
Love Guide at once. Simply clip and mail the co[upon]
below with 30c in check, cash or stamps.

CLIP AND MAIL THIS COUPON

THE HALGAR DAILY GUIDE

First, the Halgar Daily Astrological Guide a[nd]
six months for you, according to the star u[nder you]
were born. It tells you what lies ahead for y[ou in]
ness, pleasure and new friends may be co[ming.]
Then it breaks down the months into a da[ily guide]
telling you what days are best for romance, [work]
or reflection . . . and what days to be carefu[l when it]
would be unwise to take chances. You will [get a good]
deal of wonderful advice from the Daily G[uide. If fol]
lowed, may be helpful to you in many w[ays . . .]
marriage . . . business . . . health. Be sure t[o put your]
birthdate in coupon.

BOTH FOR ONLY $1 – IF YOU ACT [NOW]

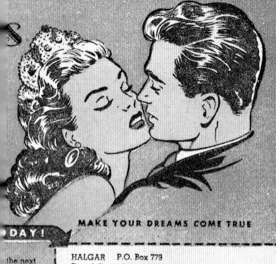

MAKE YOUR DREAMS COME TRUE

S

DAY!

the next
hich you
at happi-
our way.
ry guide,
ss, travel
when it
e a great
at, if fol-
love ...
ike your

ONCE

Wedding ETIQUETTE

SINCE NO TWENTY-FOUR HOUR SPAN IN ANY GIRL'S LIFE CAN EVER BE MORE THRILLING, IMPORTANT, AND MEMORABLE THAN HER WEDDING DAY...

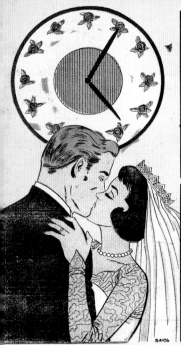

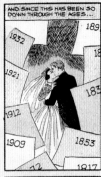

AND SINCE THIS HAS BEEN SO DOWN THROUGH THE AGES...

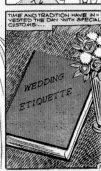

TIME AND TRADITION HAVE IN-VESTED THE DAY WITH SPECIAL CUSTOMS...

WEDDING ETIQUETTE

S4106

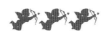

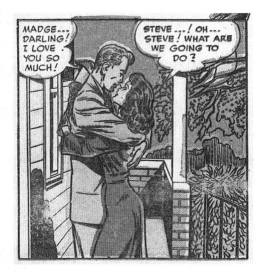

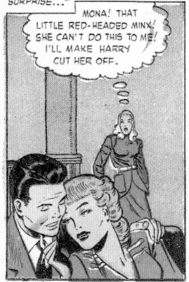

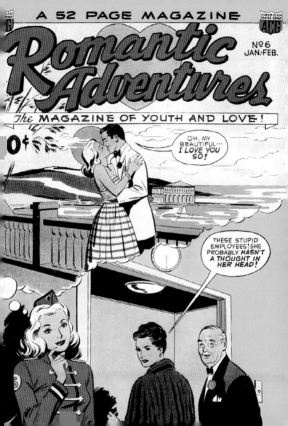

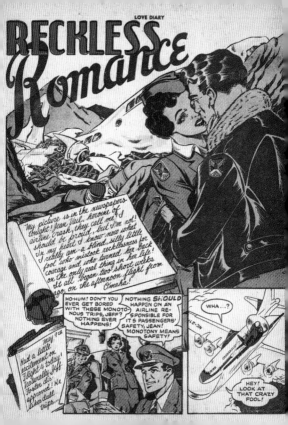

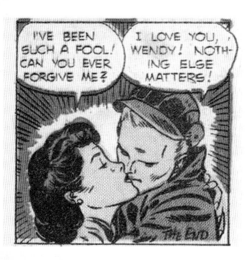

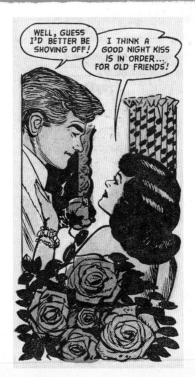

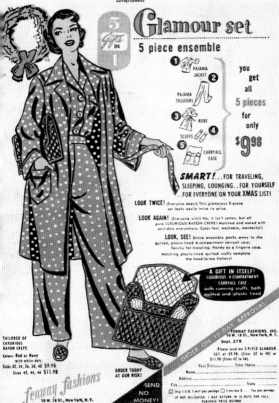

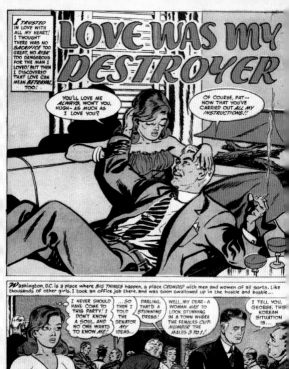

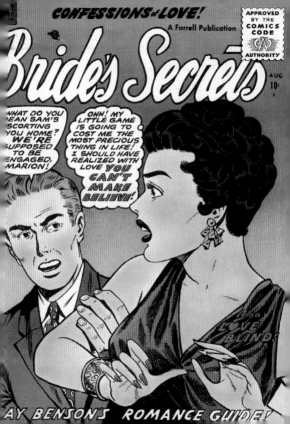